THE LITTLE BOOK OF

TATTOOS

First published in 2024 by OH
An Imprint of HEADLINE PUBLISHING GROUP

2 4 6 8 10 9 7 5 3 1

Disclaimer:

ISBN 978-1-80069-626-6

Compiled and written by: Katie Meegan
Editorial: Saneaah Muhammad
Designed and typeset in Avenir by: Stephen Cary
Project manager: Russell Porter
Production: Marion Storz
Printed and bound in China

Headline's policy is to use papers that are natural,
renewable and recyclable products and made from
wood grown in well-managed forests and other
controlled sources. The logging and manufacturing
processes are expected to conform to the
environmental regulations of the country of origin.

HEADLINE PUBLISHING GROUP
An Hachette UK Company
Carmelite House, 50 Victoria Embankment, London EC4Y 0DZ

www.headline.co.uk www.hachette.co.uk

THE LITTLE BOOK OF
Tattoos

THE WIT & WISDOM OF INK

CONTENTS

INTRODUCTION

What comes to mind when you think of tattoos? Is it "MUM" on a muscular arm? Maybe it's a delicate butterfly on an ankle? Or maybe it's a tattoo artist, covered head to toe in their own designs?

Tattoos have been around longer than #inspo pictures, longer than your gran's disapproval, hell, even longer than the world as we know it. By getting inked you are joining a centuries-old practice infused with tradition and symbolism. Yes, even that one you got as a drunken dare…

From Siberia to Polynesia, tattoos have always been part of human history. Vilified and revered, shunned and celebrated, the history of the tattoo is as colourful and detailed as a master's design.

Dive in to discover the ancient roots of tattooing, ritualistic tribal traditions and the mavericks and trailblazers that made tattooing what it is today. Searching for some inspiration for your next tat? We have you covered, with style spotlights and symbol suggestions to make your next visit to that chair a breeze.

Whether you're an aficionado or just dipping your toe into the proverbial (and literal) ink, *The Little Book of Tattoos* is about to take you on a journey…

CHAPTER

One

This old thing?

Did you know that having a tattoo links you to a deep and multicultural tradition stretching back thousands of years?

Read on to discover how t attoos are much, much older than you'd think…

"

The same fashions in…
tattooing… now prevail, and
have long prevailed, in the most
distant quarters of the world. It is
extremely improbable that these
practices, followed by so many
distinct nations, should be due
to tradition from any common
source. They indicate the close
similarity of the mind of man.

"

Charles Darwin, *The Descent of Man*, 1871.

Tattooing was practised by ancient cultures in every geographic region around the world.

Whether it was a mark of high distinction of Kings and Queens or to brand criminals, to protect in childbirth or to signify a passage to adulthood, the human urge to permanently ink our skin has been around for thousands and thousands of years.

The earliest evidence of tattoos dates back to a whopping 7,000 years ago!

Clay figurines recovered from tombs in Japan show markings or face paint that is thought to represent tattoos. These figurines are estimated to date back to around 5,000 BC or even older.

Did You Know?

Some of the oldest recorded tattoo ink recipes include vinegar, vitriol, pine bark, corroded bronze, leek juice and insect eggs.

It's enough to make your skin crawl…

The earliest physical evidence of tattoos were found on Ötzi the Iceman, a mummified Neolithic man.

Ötzi was found by tourists hiking the glaciers along the Italian-Austrian border in 1991 and is believed to have lived around 3,300 BC.

Ötzi's tattoos consist of lines and crosses along his spine, left leg and ankle. Archaeologists have found that Ötzi suffered from arthritis and other diseases, leading to the theory that the tattoo placements align with common pain-relieving acupuncture spots.

Geometric

Arguably one of the oldest designs, geometric tattoos can be identified by clean, bold lines, often found in repeating patterns. Geometric is one of the most versatile styles, easily combined with other design schools such as realistic trash polka.

In ancient Egypt, tattooing was nearly exclusively a female ritual. Several female mummies were found with tattoos on their limbs and some tomb paintings also depict tattooed women.

It is likely that the tattoos were for protection in pregnancy and childbirth.

Our bodies were printed as blank pages to be filled with the ink of our hearts.

Michael Biondi, author.

66

Usually all my tattoos came at good times. A tattoo is something permanent when you've made a self-discovery, or something you've come to a conclusion about.

99

Angelina Jolie, American actress, filmmaker and humanitarian.

When the tattooed mummy ladies were discovered in the late-19th and early- 20th centuries, the (mostly male) archaeologists of the time deduced that these were "dancing girls" of "ill repute".

However, more recent evidence has shown that they were more likely to be high priestesses and members of the royal family.

"

Anyone who's had a tattoo knows once you get your first one, as you're walking out the door, you're planning the next.

"

Chris Evans, American actor, producer and director.

Movies that have tattoos central to the plot. Could on-screen ink inspire your next one?

The Girl with the Dragon Tattoo

Memento

Eastern Promises

Moana

The Fifth Element

The Hangover Part II

Blades of Glory

Red Dragon

From Dusk till Dawn

John Wick

Harry Potter and the Half-Blood Prince

Pirates of the Caribbean: The Curse of the Black Pearl

While tattoos were associated with royalty in ancient Egypt, the opposite was true in ancient Greece and Rome.

In both eras, tattoos were used to mark slaves or criminals should they try to escape.

Did You Know?

After the Battle of Hastings in 1066, King Harold II of England's slain body was identified by his tattoos.

Harold was not the only tattooed royal either. King Edward VII had a Jerusalem Cross tattooed on his arm, and King George V had a dragon tattooed on his forearm from a visit to Japan.

Custom Script

Or in other words, words.

The text, or custom script, tattoo is a staple style for a reason. Song lyrics, poetry, literary quotes, names, mantras — the possibilities of a text tattoo are as endless as words themselves.

Tattoos are a permanent commitment of passion.

Tawny Lara, author, journalist and public speaker.

Elaborately-tattooed mummies have also been found across northern China and Siberia.

These mummies belong to the Pazyryks, formidable Iron-Age warriors who once roamed the grass plains of Eastern Europe and Western Asia.

TATTOOS

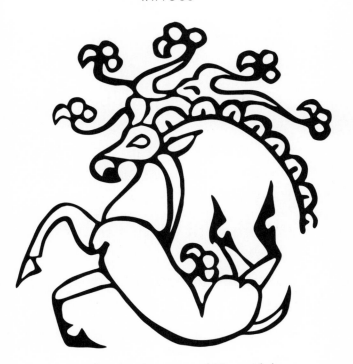

Tattoo found on the mummy of Princess Ukok,
once a part of the Pazyryk tribe, found in Siberia.

Tattoos may have been dispersed throughout the Middle East, Asia and Europe by nomadic tribes such as the Pazyryks and the Scythians.

Women of various tribes across India and the Middle East specialized in tattooing pilgrims and other travellers.

66

They keep track of time. Sometimes things happen and you feel that you need to mark them down.

99

Scott O'Connor, from his book *Untouchable*, 2011.

"The Lady of Cao"

A tattooed mummy found in Peru is one of the most ornate examples of ancient tattooing.

Dating back to 450 AD, it is thought that she was a ruler and healer, judging by the motifs in her tattoos.

Tattoos are like stories — they're symbolic of the important moments in your life. Sitting down, talking about where you got each tattoo and what it symbolizes is really beautiful.

Pamela Anderson, Canadian-American actress and model.

The word **"stigma"** is actually a Latin word, meaning to "mark" or "brand", or, more accurately, "tattoo".

Ironic, really.

"

Tattoos transform us
from raw animals into
cooked cultural beings.

"

Claude Lévi-Strauss, French anthropologist and
ethnologist.

CHAPTER

Two

Tribal Throwbacks

The ancient and unbroken practice of tattooing stretches from the Māori people of New Zealand to the First Nations tribes of the Arctic Circle.

Though they were once vilified, tribal tattoos are now a source of immense pride and identity among Native Americans, Polynesians, Aztecs and many other tribal communities.

Tribal tattoo is an umbrella term for traditional designs that originate from different ethnic groups and cultures.

Traditionally, tribal tattoos are used to show age, marital status and class.

Women's tattoos were symbols of beauty and protection, and tattos in general were used to impose a sense of identity and belonging.

Polynesia, in particular, has a rich history of tribal tattoos.

The traditional Pacific method of tattooing uses broad toothed combs of varying widths that are dipped into ink and struck into the skin with small mallets. The teeth of the comb then pierce the skin and deposit the pigment.

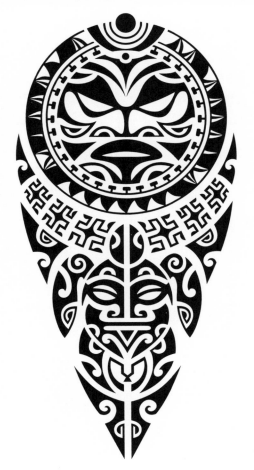

Neo-tribal

Inspired by the deep roots of the body art tradition, neo-tribal is a contemporary twist on the ancient art form. Tattooists combine different elements and styles with "tribal" elements and their own style to achieve the neo-tribal look.

I'm definitely proud of my heritage, that's why I got all the tattoos. Also I was sick of being called Māori, I'm Samoan.

Sonny Bill Williams, New Zealand heavyweight boxer and former rugby player.

The English word **"tattoo"** can be traced back to early encounters between explorers and indigenous peoples.

Tattoo is derived from the Tahitian word **"tatau"**, meaning to mark.

When in 1768, explorer Captain Cook landed in modern day Tahiti, the intricacy and skill of the tribal tattooist astounded the voyagers.

Many of the sailors got tattooed in commemoration of the journey, and Captain Cook even used the word "tattaw" in the published account of the voyage.

"
*Moko** is a statement of identity, like a passport. I am at a time in my life where I am ready to make a clear statement that this is who I am, and this is my position in New Zealand.
"

Nanaia Mahuta, New Zealand MP and member of the Waikato-Maniapoto tribe.

* *Tā Moko* is a form of body art that was brought to the Māori from Polynesia. It is considered extremely sacred and is a symbol of pride and courage.

New Zealanders are the most tattooed people in the world. This is mostly due to the island's Māori, who still get traditional Polynesian tattoos.

When missionaries arrived in Polynesia in the early-19th century, they saw tattooing as barbaric and sinful, seeking to repress it and erase thousands of years of tradition and culture.

Unfortunately, this was a pattern that was repeated throughout the colonized world.

Blackwork

Inspired by the bold, black lines of tribal tattoos, blackwork is a modern spin on classic techniques.

This style of design incorporates geometric shapes, negative space, thick lines and dotwork, and they can be both minimal or intricate.

"

The story of my tattoos is a very elaborate story that are all the things that are important to me and that I'm passionate about and that move me to the heart. It all comes down to three things: my family, protecting my family and having a very aggressive warrior spirit.

"

Dwyane "The Rock" Johnson, American actor and professional wrestler.

Starstruck?

Here are some famous actors with
tattoos to provide inspiration…

Pete Davidson

Johnny Depp

Dwayne "The Rock" Johnson

Angelina Jolie

Scarlett Johansson

Sophie Turner

Ryan Reynolds

Brad Pitt

Jason Momoa

Zoë Kravitz

"

It's an *aumakua**, so this is the shark, the *mano***, which is my protector.

"

Jason Momoa, American actor, on his traditional Hawaiian tatttoo.

* In Hawaiian mythology, an *aumakua* is a deified ancestor who takes on a physical form to watch over their families.

** "Mano" is the Hawaiian word for "shark".

Did You Know?

In Polynesian societies, pain was an intrinsic part of the tattooing process.

In Tahiti, a chief's son could lose his position for showing signs of pain during tattooing. In Samoa, the pain of tattooing was said to give men an idea of the pain of childbirth.

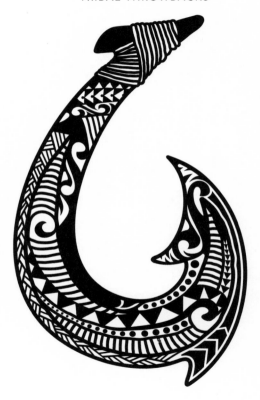

I got this [tattoo] in Samoa and it was brutal. It was the most pain I had ever felt. All the lines tell different stories of Samoan heritage and I have five stars on my elbow which represent the Samoa flag. It took 14 hours.

Manu Tuilagi, professional rugby player.

Black ink is easier to remove than yellow ink.

Contrary to common belief, black ink (along with dark green) is easier to remove that lighter colors like yellow or purple. The reason is that different dyes respond to different light wavelengths.

At the age of 106,
Apo Whang-Od is the oldest
woman ever to grace the
cover of *Vogue*.

Why? Because she is also
the oldest remaining
mambabatok, or traditional
Kalinga tattooist, left in the
Philippines. Whang-Od was
trained in batok tattooing
by her father, which is now a
highly-endangered skill.

Tattooing has been practised for millennia by Inuit women of the Iñupiat and Yup'ik tribes.

A collection of lines and symbols tattooed on the face, these tattoos mark important events in the woman's life, such as first love, the birth of a child or the transition to womanhood.

"

Our tattoos tell our story in different ways.

"

Quannah Chasinghorse, model, actress and Indigenous activist.

There has been a recent revival in tribal tattoos, with more people understanding the proud history and heritage of the art form.

Many tribal tattoo artists today use a combination of the traditional tattooing methods with modern tattoo guns and needles.

The debate is ongoing as to whether tribal tattoos are appropriate for those outside of the communities from which the designs originate.

There are arguments for both sides, so do your design research before committing to that tat.

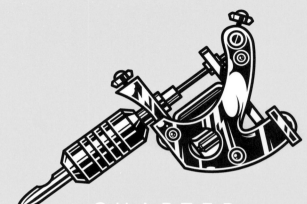

CHAPTER

Three

Inker, Sailor, Soldier, Spy

Whether it's Popeye's famous anchor tattoo or a regiment number, centuries of tattoos from soldiers and sailors still influence many of today's most sought-after styles.

After Captain Cook and
his crew popularized the
term tattoo in the late-18th
century, the practise of
tattooing slowly became more
widespread across Europe.

A superstitious bunch,
sailors sought safety in the
amulet-like power of tattoos,
believing that symbols
such as anchors would keep
them safe from harm.

Miners also embraced the power of tattoo protection, with lamps tattooed on their forearms to safely bring them above ground again.

Tattoo is the magic word. It hits people in a way that no other visual medium does. And it is not simply visual, but visceral. Everybody has an opinion about it and everybody has a gut reaction. And because they are permanent, tattoos raise all these issues about life and death.

Don Ed Hardy, American tattoo artist.

Old School Traditional

Probably the first type of design that pops into your grandmother's head when you say "tattoo". Old School, Classic Americana and Traditional American are all names for the same type of timeless vintage style. This style is characterized by bold saturated colours, two-dimensional images and thick, black outlines.

Did You Know?

For sailors, different tattoos symbolized their adventures.

Read on for a full list of what traditional sailor tattoos mean!

A **pig** and a **rooster** on each foot was said to protect the sailor from drowning.

As neither animal can swim, they would guide the sailor to the nearest shore.

A **full-rigged ship** meant that the seaman had sailed around Cape Horn, a notoriously treacherous journey.

The iconic **anchor** tattoo meant that the sailors had travelled the Atlantic Ocean, and was also used for protection.

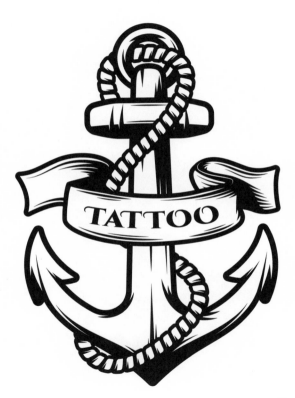

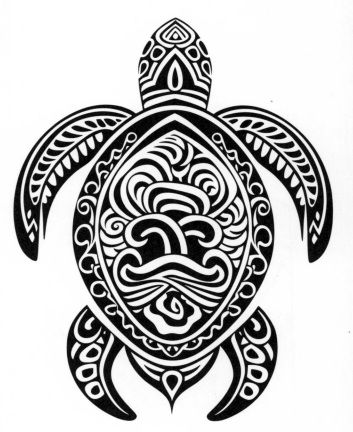

74

A **shellback turtle** denoted that that sailor had crossed the equator.

A **swallow** tattoo showed how far a sailor travelled – usually one swallow for every 5,000 nautical miles!

Dragons were also a common nautical tattoo.

A **red dragon** showed that the sailor had served at a Chinese station.

A **golden dragon** meant that they had crossed the international date line.

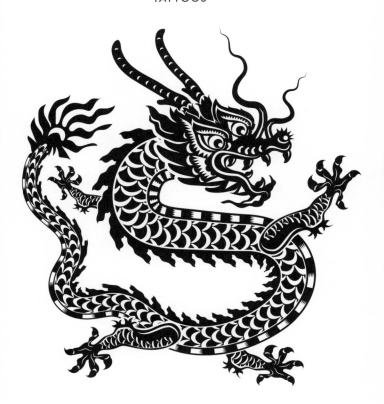

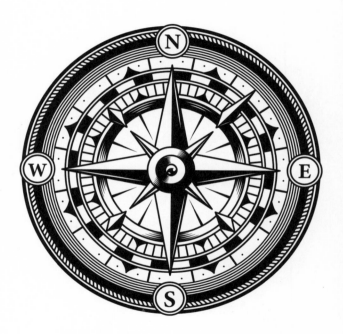

Nautical stars and **compasses** were thought to help the sailor find their way home.

Hula girls and **palm trees** were common among American soldiers and expressed that they had been stationed in Hawaii.

A **rope** around the forearm of a sailor showed that they were a deckhand.

When tattooed across the knuckles, **"HOLD"** and **"FAST"** were to remind the deckhand to grip the rigging better.

Did You Know?

The word "tattoo" is one of the most misspelled words in the English language.

It is commonly spelled as "tatoo."

"

Show me a man with
a tattoo and I'll show
you a man with an
interesting past.

"

Jack London, American novelist, journalist and activist.

The practice of tattooing spread quickly among sailors of all nationalities.

American sailors adopted the practice of tattooing to declare their citizenship and avoid being forcibly recruited by the British Navy.

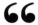

It wasn't so much about what I was tattooing on my body. It was where, the time and place, and the memories.

Ed Sheeran, singer-songwriter, on the meaning behind his tattoos.

Singers with tattoos?

That's music to our ears!

Lady Gaga
Rihanna
Adele
Miley Cyrus
Ariana Grande
Zayn Malik
Joe Jonas
Post Malone
Justin Bieber
Harry Styles
Adam Levine
Drake
Christina Aguilera
Demi Lovato

The meeting of navy sailors and soldiers during the American Civil War is thought to have birthed the military tattoo.

These tattoos spread quickly – leading historians estimate that by the end of World War I, 90% of American soldiers had at least one tat.

99.9%

Gregory Paul McLaren holds the Guinness World Record for being the most tattooed person.

He is 99.9% covered, including the inside of his eyelids, mouth and ears!

New School

Originating in the 1970s, this style is a modern twist on Traditional Americana designs. New School designs keep the bold outlines of the old school styles, adding in more vibrant colours, shading and 3D effects and cartoon-like element exaggeration. If you're considering a comic book character or something similar as your next tattoo, then this is the style for you.

All my tattoos, they've been thought out, thought over, been a work in progress for at least a year before I've got them. So I'm not walking into a tattoo shop, picking tattoos off a wall. It's something that means something to me. It's something that I believe in.

Colin Kaepernick, former American football player and civil rights activist.

Technically, all tattoos are temporary, even permanent ones.

Mokokoma Mokhonoana, author and poet.

Throughout history, tattoos have both helped and hindered the most secretive profession of them all – espionage.

While most intelligence agencies discourage visible tattoos, many undercover operatives have used tattoos to solidify their fake identity.

You've heard of tattoos being used to identify fraudsters, but what about a lack of them? Tattoos, that is, not con artists.

Arthur Orton shocked Victorian society by claiming to be Roger Tichborne, shipwreck victim and heir to a large family fortune. However, Orton was revealed to be an imposter as he did not have the same tattoo as Tichborne, leading to a scandalous legal case.

I am so intrigued by tattoos. It's an entire culture, and I study it.

Rihanna, singer-songwriter, on her fascination with tattoos.

"

I just like tattoos.

"

Amy Winehouse, singer-songwriter, on the simplicity
of liking tattoos.

The US Army's recruiting drive for World War II caused an unexpected tattooing boom.

Due to a ruling over "indecent or obscene tattooing", many eligible young men rushed to add lingerie, skirts, brassieres, fans, bubbles, flowers and butterflies to pictures of nude women that they previously had tattooed.

Military tattoos are often
used to commemorate time
served or fallen colleagues.

Did You Know?

In Soviet Russia, some prisoners would get tattoos of communist leaders Lenin and Stalin.

However, this was nothing to do with political affiliation, but protection. In case they were sentenced to death, the prisoners could not be executed by firing squad, as it was illegal to shoot at images of their national leaders.

Today, American traditional and neo-traditional styles of tattooing can all trace their roots back to the sailors of the high seas.

CHAPTER

Four

Tools, Trades and Trapeze Artists

So how did tattooing go from traditional methods to the modern-day studio?

Well, the stories behind the pioneers of modern tattooing are as colourful and varied as their designs…

"Stick and poke" is the oldest recorded tattooing method, extending across many cultures and styles.

Over centuries, the worldwide practice of stick and poke tattoos included needles made of wood, bone fragments or thin sharp blades.

Nowadays, you're more likely to be tattooed with a needle than with a sharpened animal bone…

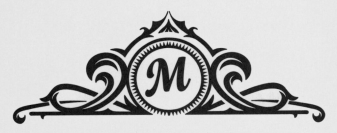

Minimalist

Make a big statement without an elaborate design with a minimalist tattoo.

Often small in size, these designs are known for delicate and sometimes abstract lines, usually in black. Minimalist styles are a great choice for your first tattoo.

I am a canvas of my experiences, my story is etched in lines and shading, and you can read it on my arms, my legs, my shoulders and my stomach.

Kat Von D, Mexican-American tattoo artist and entrepreneur.

The tattoo gun as we know it today was the brainchild of Irish-American artist Samuel O'Reilly.

After deserting the navy where he likely learned the art of tattooing from his fellow seamen, O'Reilly opened a tattoo shop in the Chinatown district of New York in 1875.

Taking one of Thomas Edison's failed electric pen experiments, O'Reilly immediately saw its potential for tattooing.

Through testing trial and error, O'Reilly invented something that revolutionized tattooing forever – the handheld tattoo machine.

With traditional hand-poking, even the most experienced tattoo artist could only puncture the skin at a rate of two or three times a second.

O'Reilly's tattoo machine increased this to around 50 perforations per second.

O'Reilly's studio was soon inundated with customers wanting to be tattooed with his new machine.

He would also travel to tattoo wealthy clientele who did not want to be seen in his Chinatown studio.

Soon, there were tattoo studios in every major US and European city.

Did You Know?

A tattoo gun penetrates the skin about one millimetre deep.

Ink is injected directly into the second layer of skin, referred to as the "dermis". The skin atop the dermis is called the "epidermis" and acts as a sheer veil over top of the actual tattoo.

66

Tattoos… are the stories
in your heart, written
on your skin.

99

Charles De Lint, Canadian author.

The advent of the tattoo gun also saw the rise of the **flash tattoo**.

The flash tattoo is a design that is quick and relevantly easy to reproduce.

Skilled professional artists would often sell designs on thin paper to be traced and inked cheaply in street shops.

The most well-known artist
to have popularized
flash designs was Lewis Albert
(1880–1954), the son of
Jewish immigrants.

Professionally known as
"Lew the Jew", Lewis ran a
successful tattoo business in
New York City for over
25 years.

Many classic designs can be
traced back to him today.

Did You Know?

One of the most famous tattoo artists of the early-20th century was a woman. Her name was Maud Wagner and she was a total badass.

Maud first made a living as an acrobat, before meeting Gus Wanger, also known as the "Tattooed Globetrotter".

Gus initially tattooed Maud in order to get a date…

It obviously worked as the pair married and Gus continued to teach Maud how to tattoo herself and others.

Eventually, Maud's body was almost entirely tattooed, making her a carnival spectacle of her own.

While many women had been tattooed before her, Maud was the first woman of her era to learn the art of tattooing herself, paving the way for a new generation of female tattooists.

Realism

Get comfortable in that chair cause this one is gonna take a while! Modern, classic, realist tattoos are life-like and intricately detailed designs — so life-like that they nearly jump off the skin! Usually, realist tattoos are medium-to-large in size, accounting for the amount of fine detail and shading required. Other subgenres of the realist tattoo are photo-realistic and hyper-realistic.

People are proud of their tattoos. It's like a modern coat of arms.

Christian Louboutin, French fashion designer.

See tattoos as a goal?

Well so do these famous
sportspeople…

David Beckham

Mike Tyson

Lionel Messi

Zlatan Ibrahimovic

LeBron James

Kobe Bryant

Simone Biles

Serena Williams

Amy "Lita" Dumas

Megan Rapinoe

My body is my journal,
and my tattoos are
my story.

Johnny Depp, American actor and musician.

Tattooing and circuses have a long, colourful history.

From the late-19th to the early-20th century, every major circus had at least one entirely tattooed person.

Rival circuses competed for the most elaborate designs and paid the performers handsomely.

While these exhibitions were entertaining to audiences of the time, the ethics of these "freakshows" didn't age well.

Early shows included "tattooed savages" often forcibly taken from their homes, or those who claimed to have been captured by "natives" and tattooed against their will, regaling their audiences with tales of adventure.

Did You Know?

A tattoo gun can puncture the skin between 50 and 3,000 times per minute.

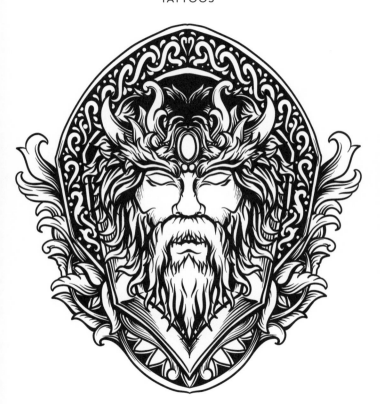

I want my tattoos to
be a story of my life.

Anne-Marie, singer-songwriter.

Apprentice tattoo artists enjoy getting a little fruity…

Not in that way! Aspiring tattoo artists usually hone their skills by practising on grapefruit, oranges and lemons.

Apparently, citrus fruits have the closest texture to human skin.

66

I always liked the idea of shaving the back of my head and getting a tattoo of my own face there so that, whichever way I was looking, I could freak people out.

99

Jon Hopkins, musician and producer.

Innovators, mavericks and performers, we have a lot to thank these pioneering tattoo artists for.

Daring to be ahead of their time, could they inspire your next tattoo?

Five

Beast Mode

Humans have been tattooing animals on ourselves for thousands of years.

Across cultures, animals symbolize strength, protection, wisdom or even just your favourite pet.

Just like the thousands of species found in the animal kingdom, there are thousands of animals to turn into tattoos, and even more styles to design them in!

Read on to discover what some common animal tattoos mean, and find your perfect fit…

"

Tattooing is about personalizing the body, making it a true home and fit temple for the spirit that dwells inside it.

"

Michelle Delio, author, on the connection between tattoos and the soul.

The king of the jungle, **lions** represent strength, courage, leadership and family.

Another big cat, **tigers** can symbolize pride, independence, freedom, confidence and courage.

Leopards show strength, confidence and fierceness.

Snakes tend to get a bad rep in mythology (something about an apple?) but in terms of tattooing, their meaning can run much deeper.

Thanks to shedding their skin, snakes can be seen as symbols of change, transformation, commitment to knowledge, healing or connection to spirituality.

Tattoos were fashionable among aristocrats in the late-19th and early-20th centuries. At the time, tattooing was so expensive that only the wealthy could afford to have it done professionally, but this changed when it became more widespread.

Winston Churchill's mother, Lady Randolph Churchill, had a snake tattooed on her wrist.

The symbolism behind the **deer** tattoo can be mainly traced back to Native American mythology. The deer represents sensitivity, intuition, gentleness, peacefulness and healing.

Resourceful and clever, the **fox** is the tattoo to consider if you want a symbol of resilience, beauty, intelligence and playfulness.

Wide-eyed and nocturnal, **owls** are one of the most popular bird tattoos. Seen as guardians of wisdom, owls tend to symbolize knowledge, mystery, the supernatural or messengers from other worlds.

Crows get a bad name as harbingers of death and doom but in reality, crows are incredibly intelligent. Some now see them as symbols of mystery, magic and good fortune.

"

For me, a tattoo is an art installation that I get to wear all the time. It's all about self-expression. You get to wear your insides on your outsides.

"

Malia Jones, American model and surfer.

Watercolour

Watercolour designs are all about whimsy and fluidity.

Mimicking a lush painting, watercolour designs are known for their blended and vibrant strokes of colour.

Japanese **Koi Fish** have various meanings depending on their size, placement and colour.

Red koi fish symbolizes power, love, bravery and motherhood.

White koi fish symbolizes success, power of transformation, growth and rebirth.

Blue or **black koi** fish symbolize masculinity and triumph over life's battles.

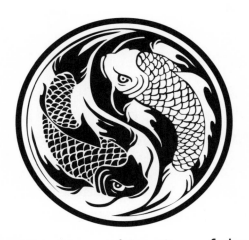

Creating a combination of these colours on a koi fish tattoo creates a more personalized and unique meaning.

"

Express yourself through your art – whether it's your drawings in a sketchpad, tattoos on your skin, the shade of your lipstick or the clothes that you wear.

"

Kat Von D, Mexican-American tattoo artist.

Binge-worthy series that
may well give you some tat inspo…

Sons of Anarchy
Blindspot
Prison Break
American Horror Story: Apocalypse
Vikings
Buffy the Vampire Slayer
Pam & Tommy
LA Ink

"
I look at tattoos as
a commitment to life.
"

Jeff Hardy, American wrestler and musician.

According to ancient civilizations, **wolves** represent divinity, rebirth and spirituality. Today their meaning is more fluid, encompassing leadership, resilience, power, unity, protection and family.

A man's (and woman's) best friend, **dogs** are symbols of unwavering loyalty, devotion, sincerity, bravery and playfulness.

Paw print tattoos are also a meaningful way to commemorate your pooch.

Revered as gods by the ancient Egyptians, **cats** still carry associations with the afterlife and spirituality.

A cat tattoo can symbolize intelligence, independence and creativity.

Because of their nine lives, cats can also represent resilience and the ability to always land on your feet.

A **black cat** can represent either good or bad luck (depending on your culture), mystery, mysticism and magic.

Celtic

Celtic style tattoos are inspired by artistic traditions of Celtic nations.

Often intricate designs, Celtic tattoos usually contain a play on motifs of knotwork, Celtic crosses, spirals, animals and plants.

Characteristic of their home in China and the Far East in general, **pandas** symbolize prosperity, good luck and living a harmonious and peaceful life.

Gentle giants, **elephants** are a symbol of quiet strength. Powerful and peaceful, they symbolize family, love and protection.

One of the oldest tattoo designs, **turtles** symbolize long life, perseverance, good luck, patience, stability and wisdom.

A popular and tropical choice, **dolphins** represent inner strength, peace, compassion and kindness.

Nature's hardest workers, **bee** tattoos symbolize teamwork, loyalty, love and family.

Adding a royal twist, a **queen bee** tattoo can mean power and leadership, running the hive like a total boss.

The tattoo attracts and also repels precisely because it is different. 🙶🙶

Margo DeMello, cultural anthropologist.

Creatures of transformation, **butterflies** represent personal development and positive change.

Different colours and eye-catching designs can also create deeper meanings, making butterflies a popular tattoo choice.

The meaning behind **dragon** tattoos is as varied and far-reaching as their lore. Depending on where they come from, dragons can represent power and strength, wisdom and knowledge, protection, transformation and rebirth, balance and harmony.

Another mythological creature, the **phoenix** represents rebirth, resilience and immortality.

CHAPTER

Six

It's Symbolic, Duh

While all tattoos are symbolic in their own way, humans have a tendency to take meaningful symbols and motifs and turn them into striking body art.

All tattoos are symbolic but here are some of the most common symbols and what they mean.

Obviously, some symbols have spiritual meanings and are deeply significant to different cultures, so do your research before hopping on that tattoo shop chair!

The body part tattooed
the most among women is
the ankle area.

Among men, the most
common spot is the arm.

Originating in ancient Confucian philosophy, **Yin and Yang** tattoos symbolize unity in opposites.

The balance of yin-yang is central in its symbolic appeal.

Yin, the black side, embodies femininity, earth and the spirit of all things. While **yang**, embodies masculinity, heaven and the form of all things.

" The tattoo represents not only a willingness to accept pain, to endure it but a need to actively embrace it. Because life is painful, beautiful but painful. "

Nicola Barker, novelist and short story writer.

Kanji tattoos are symbols or characters of simplified Chinese origin.

These symbols can be elegant and understated but do always double check that your tattoo actually means what you think it does!

Irezumi
(Traditional Japanese)

Dating from the Edo period (1603–1868), these intricate Japanese designs are rooted in folklore and legend. Common motifs include lotus flowers, Buddhas, waves, koi fish and dragons. Stylistically, these tattoos are often two-dimensional with curvy lines and bold traditional colours.

Originally a scientific symbol, the **infinity sign** is a never-ending loop representing never-ending possibilities, eternal love and connection.

Why not add your own meaning to it to intensify the power of infinity?

Popularized by the hippy movement of the sixties and seventies, the **peace sign** symbolizes an opposition to conflict, war and desire to live in a harmonious world.

66

A tattoo is an affirmation:
that this body is yours
to have and to enjoy
while you're here.
Nobody else can control
what you do with it.

99

Don Ed Hardy, American tattoo artist.

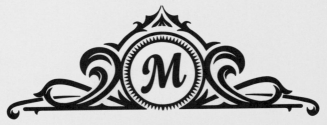

Mandalas

From the Sanskrit word of "circle", mandala tattoos invoke peace, love and mindfulness.

Balance and harmony are central to the mandala design, encapsulated by fine lines in geometrical patterns, circular around a central symbol and symmetry.

Fancy a floral arrangement?

There's more symbolism to flowers than you might think…

Roses represent love, friendship and connection.

Daisies represent innocence, purity and true love.

Lotus Flowers represent life's journey, enlightenment and personal growth.

Sunflowers symbolize warmth, creativity and happiness.

Angels have various spiritual meanings such as connection to a loved one who has passed away, resurrection, rebirth or connection to a higher power.

Angel wings have a similar meaning to angel tattoos but can also mean freedom, faith and protection.

Sun tattoos have various meanings depending on their position.

A rising sun can represent new beginnings, or a sun with three stars can commemorate a spiritual event.

Moon tattoos are a symbol of mystery, feminine energy and cyclical change.

Moon tattoos can also be interpreted as representing the ebb and flow of life.

Did You Know?

Musician Tommy Lee set a Guinness World Record when he became the first man to be tattooed mid-air (on a plane, obviously) in 2007.

Tattoos tell stories of crime and passion, punishment and regret. They express an outlaw, antiauthoritarian point of view and communicate romantic solidarity among society's outcasts.

Douglas Kent Hall, American writer and photographer.

Getting your **astrological sign** tattooed is a great representation of your characteristics and where you come from.

Some also opt for the astrological signs of loved ones.

Semicolon tattoos
represent the continuation
of life and show that
the wearer's story is not over.

Since 2013, the semicolon
tattoo has become a symbol
of mental health awareness.

"

You don't choose your tattoo design, your tattoo chooses you!

"

Shirin Naghashlou, tattoo artist.

Model behaviour… you didn't think
some of the most famously-gorgeous faces
wouldn't have tattoos, did you?

Cara Delevigne

Hailey Bieber

Bella Hadid

Gisele Bündchen

Kate Moss

Kendall Jenner

Chanel Iman

Lily Cole

Adriana Lima

Jeremy Meeks
(aka The Hot Convict)

Candles represent light in dark times, enlightenment, wisdom or faith.

They can also represent honouring memories of loved ones or life celebrations.

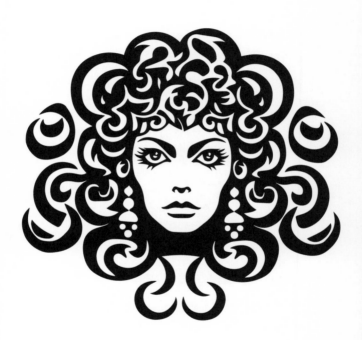

Tattoos of **Medusa**, the figure from Greek mythology with snakes in her hair and the ability to turn people into stone, is a symbol of protection and female empowerment.

The medusa tattoo has become an emblem of increasing awareness of sexual assault and has been reclaimed as a symbol of strength.

"

All my tattoos, they've been thought out, thought over, been a work in progress for at least a year before I've got them. So I'm not walking into a tattoo shop, picking tattoos off a wall. It's something that means something to me. It's something that I believe in.

"

Colin Kaepernick, former American football player and civil rights activist.

Did You Know?

The record for the longest tattoo session is 56 hours and 30 minutes.

The artist, Krzysztof Barnas, finished 11 tattoos, and he was only allowed 5 minutes after every hour to rest.

191

66

If the body is a temple,
then tattoos are its
stained glass windows.

99

Sylvia Plath, American poet and novelist.